2021

M	18	22	22	19	17	21	19	16	20	18	22	20
T	19	23	23	20	18	22	20	17	21	19	23	21
W	20	24	24	21	19	23	21	18	22	20	24	22
T	21	25	25	22	20	24	22	19	23	21	25	23
F	22	26	26	23	21	25	23	20	24	22	26	24
S	23	27	27	24	22	26	24	21	25	23	27	25
S	24	28	28	25	23	27	25	22	26	24	28	26
M	25	29	29	26	24	28	26	23	27	25	29	27
T	26	30	30	27	25	29	27	24	28	26	30	28
W	27	31	31	28	26	30	28	25	29	27		29
T	28			29	27		29	26	30	28		30
F	29			30	28		30	27	31	29		31
S	30				29		31	28		30		
S	31				30			29		31		
M					31			30				
T								31				

A Little Bit About

New Internationalist

...................

At New Internationalist we believe that equality improves life in every way, and that when people come together to confront injustice – be it social, environmental or economic – wonderful things can happen. New Internationalist is part of a global movement, forging ties and framing the arguments for genuine change.

An independent, not-for-profit media co-operative, New Internationalist is a voice that empowers. We tell the stories that the mainstream media sidestep and offer a platform for the people living those stories. Our award-winning magazine, books and website set the agenda for a radically fairer future, promote global justice and campaign for the disadvantaged all over the world.

Ni

For more information visit

NEWINT.ORG

To get more copies or re-order this diary, and buy more ethical and fairly traded gifts, visit our online shop:

NEWINT.ORG/SHOP

Personal Info

Name

Address

Phone

Mobile

College/work address

Passport number

National insurance number

Doctor

Dentist

Other

IN CASE OF EMERGENCY

Name

Address

Phone

Mobile

Other

2020

(The 2021 calendar can be found inside the cover at the front of this planner)

JANUARY
M	T	W	T	F	S	S
		1	2	3	4	5
6	7	8	9	10	11	12
13	14	15	16	17	18	19
20	21	22	23	24	25	26
27	28	29	30	31		

FEBRUARY
M	T	W	T	F	S	S
					1	2
3	4	5	6	7	8	9
10	11	12	13	14	15	16
17	18	19	20	21	22	23
24	25	26	27	28	29	

MARCH
M	T	W	T	F	S	S
						1
2	3	4	5	6	7	8
9	10	11	12	13	14	15
16	17	18	19	20	21	22
23	24	25	26	27	28	29
30	31					

APRIL
M	T	W	T	F	S	S
		1	2	3	4	5
6	7	8	9	10	11	12
13	14	15	16	17	18	19
20	21	22	23	24	25	26
27	28	29	30			

MAY
M	T	W	T	F	S	S
				1	2	3
4	5	6	7	8	9	10
11	12	13	14	15	16	17
18	19	20	21	22	23	24
25	26	27	28	29	30	31

JUNE
M	T	W	T	F	S	S
1	2	3	4	5	6	7
8	9	10	11	12	13	14
15	16	17	18	19	20	21
22	23	24	25	26	27	28
29	30					

JULY
M	T	W	T	F	S	S
		1	2	3	4	5
6	7	8	9	10	11	12
13	14	15	16	17	18	19
20	21	22	23	24	25	26
27	28	29	30	31		

AUGUST
M	T	W	T	F	S	S
					1	2
3	4	5	6	7	8	9
10	11	12	13	14	15	16
17	18	19	20	21	22	23
24	25	26	27	28	29	30
31						

SEPTEMBER
M	T	W	T	F	S	S
	1	2	3	4	5	6
7	8	9	10	11	12	13
14	15	16	17	18	19	20
21	22	23	24	25	26	27
28	29	30				

OCTOBER
M	T	W	T	F	S	S
			1	2	3	4
5	6	7	8	9	10	11
12	13	14	15	16	17	18
19	20	21	22	23	24	25
26	27	28	29	30	31	

NOVEMBER
M	T	W	T	F	S	S
						1
2	3	4	5	6	7	8
9	10	11	12	13	14	15
16	17	18	19	20	21	22
23	24	25	26	27	28	29
30						

DECEMBER
M	T	W	T	F	S	S
	1	2	3	4	5	6
7	8	9	10	11	12	13
14	15	16	17	18	19	20
21	22	23	24	25	26	27
28	29	30	31			

2022

JANUARY
M	T	W	T	F	S	S
					1	2
3	4	5	6	7	8	9
10	11	12	13	14	15	16
17	18	19	20	21	22	23
24	25	26	27	28	29	30
31						

FEBRUARY
M	T	W	T	F	S	S
	1	2	3	4	5	6
7	8	9	10	11	12	13
14	15	16	17	18	19	20
21	22	23	24	25	26	27
28						

MARCH
M	T	W	T	F	S	S
	1	2	3	4	5	6
7	8	9	10	11	12	13
14	15	16	17	18	19	20
21	22	23	24	25	26	27
28	29	30	31			

APRIL
M	T	W	T	F	S	S
				1	2	3
4	5	6	7	8	9	10
11	12	13	14	15	16	17
18	19	20	21	22	23	24
25	26	27	28	29	30	

MAY
M	T	W	T	F	S	S
						1
2	3	4	5	6	7	8
9	10	11	12	13	14	15
16	17	18	19	20	21	22
23	24	25	26	27	28	29
30	31					

JUNE
M	T	W	T	F	S	S
		1	2	3	4	5
6	7	8	9	10	11	12
13	14	15	16	17	18	19
20	21	22	23	24	25	26
27	28	29	30			

JULY
M	T	W	T	F	S	S
				1	2	3
4	5	6	7	8	9	10
11	12	13	14	15	16	17
18	19	20	21	22	23	24
25	26	27	28	29	30	31

AUGUST
M	T	W	T	F	S	S
1	2	3	4	5	6	7
8	9	10	11	12	13	14
15	16	17	18	19	20	21
22	23	24	25	26	27	28
29	30	31				

SEPTEMBER
M	T	W	T	F	S	S
		1	2	3	4	
5	6	7	8	9	10	11
12	13	14	15	16	17	18
19	20	21	22	23	24	25
26	27	28	29	30		

OCTOBER
M	T	W	T	F	S	S
					1	2
3	4	5	6	7	8	9
10	11	12	13	14	15	16
17	18	19	20	21	22	23
24	25	26	27	28	29	30
31						

NOVEMBER
M	T	W	T	F	S	S
	1	2	3	4	5	6
7	8	9	10	11	12	13
14	15	16	17	18	19	20
21	22	23	24	25	26	27
28	29	30				

DECEMBER
M	T	W	T	F	S	S
			1	2	3	4
5	6	7	8	9	10	11
12	13	14	15	16	17	18
19	20	21	22	23	24	25
26	27	28	29	30	31	

2021 Dates and Holidays

JANUARY

1 New Year's Day
(Aus, Can, NZ, UK, US)
4 Public Holiday *(NZ, Scot)*
6 Epiphany *(Christian)*
13 Maghi *(Sikh)*
18 Martin Luther King Jr Day *(US)*
26 Australia Day/Invasion Day *(Aus)*
28 Tu B'Shvat *(Jewish)*,
Mahayana Buddhist New Year

FEBRUARY

2 Imbolc *(Wicca)*
3 Setsubun-sai *(Shinto)*
6 Waitangi Day *(NZ)*
8 Nirvana Day *(Buddhist)*
12 Chinese New Year
14 Valentine's Day
15 Presidents' Day *(US)*
16 Vasant Panchami *(Hindu)*,
Shrove Tuesday *(Christian)*
17 Ash Wednesday *(Christian)*
26 Purim *(Jewish)*

MARCH

8 International Women's Day
11 Maha Sivaratri *(Hindu)*
14 Clocks change *(Can/US)*
17 St Patrick's Day *(Ire)*
20 Equinox
22 World Water Day
28 Clocks change *(Europe)*,
Passover begins *(Jewish)*,
Palm Sunday *(Christian)*
29 Holi *(Hindu)*
Hola Mahalla *(Sikh)*

APRIL

2 Good Friday *(Christian)*
4 Clocks change *(Aus/NZ)*,
Easter Day *(Christian)*
5 Public holiday
(Aus, Can, NZ, UK except Scot)
7 World Health Day
8 Yom Hashoah *(Jewish)*,
Visakha Puja *(Buddhist)*

13 Ramadan begins *(Muslim)*
14 Baisakhi *(Sikh New Year)*
22 Earth Day
25 Anzac Day *(Aus/NZ)*
27 Theravada Buddhist New Year

MAY

1 International Workers' Day
Beltane/Samhain *(Wicca)*
3 Public holiday *(UK)*
13 Eid al Fitr *(Muslim)*, Ascension
Day *(Christian)*
17 Shavuot begins *(Jewish)*
23 Pentecost *(Christian)*
24 Victoria Day *(Can)*
29 Ascension of the
Baha'u'llah *(Baha'i)*
31 Public Holiday *(UK)*,
Memorial Day *(US)*

JUNE

5 World Environment Day
7 Queen's Birthday *(NZ)*
8 World Oceans Day
14 Queen's Birthday *(Aus)*
20 World Refugee Day
Pentecost *(Orthodox Christian)*
21 Solstice

JULY

1 Canada Day *(Can)*
4 Independence Day *(US)*
13 Obon *(Shinto)*
20 Eid al Adha *(Muslim)*

AUGUST

2 Public holiday *(Scot)*
10 Hijra/New Year *(Muslim)*
12 International Youth Day
19 Ashura *(Muslim)*
30 Public Holiday *(UK except Scot)*

SEPTEMBER

6 Labour Day *(Can)*,
Labor Day *(US)*

7 Rosh Hashanah begins *(Jewish)*
16 Yom Kippur *(Jewish)*
21 Sukkot begins *(Jewish)*
22 Equinox
26 Clocks change *(NZ)*

OCTOBER

3 Clocks change *(Aus)*
4 Labour Day *(Aus)*
5 World Teachers' Day
6 Navaratri begins *(Hindu)*
11 Thanksgiving *(Can)*
Indigenous Peoples' Day/
Columbus Day *(US)*
16 World Food Day
18 Mawlid al-Nabi *(Sunni Muslim)*
23 Mawlid al-Nabi *(Shia Muslim)*
25 Labour Day *(NZ)*
31 Clocks change *(Europe)*,
Halloween

NOVEMBER

4 Diwali *(Hindu, Sikh, Jain)*
7 Clocks change *(Can/US)*
11 Veterans' Day *(US)*,
Remembrance Day *(Can)*
13 Jain New Year
25 Thanksgiving *(US)*,
International Day for the
elimination of violence against
women
28 First Sunday of
Advent *(Christian)*
29 Hanukkah begins *(Jewish)*

DECEMBER

1 World AIDS Day
21 Solstice
25 Christmas Day *(Christian)*
26 Boxing Day
27 Public holiday
(Aus, Can, NZ, UK)
28 Public holiday
(Aus, Can, NZ, UK)

1 FRIDAY *New Year's Day (Aus, Can, NZ, UK, US)*

2 SATURDAY

3 SUNDAY

NOTES

January

4 **MONDAY** *Public holiday (NZ, Scot)*

5 **TUESDAY**

6 **WEDNESDAY** *Epiphany (Christian)*

7 **THURSDAY**

WEEK 1

8 FRIDAY

9 SATURDAY

10 SUNDAY

NOTES

January

11 MONDAY

12 TUESDAY

13 WEDNESDAY *Maghi (Sikh)*

14 THURSDAY

15 FRIDAY

16 SATURDAY

17 SUNDAY

NOTES

January

18 MONDAY · *Martin Luther King Jr Day (US)* · · · ·

19 TUESDAY

20 WEDNESDAY

21 THURSDAY

22 FRIDAY

23 SATURDAY

24 SUNDAY

NOTES

January

25 MONDAY

26 TUESDAY *Australia Day/Invasion Day*

27 WEDNESDAY

28 THURSDAY *Tu B'Shvat (Jewish), Mahayana Buddhist New Year*

29 FRIDAY

30 SATURDAY

31 SUNDAY

NOTES

January WEEK 4

1 MONDAY

2 TUESDAY *Imbolc (Wicca)*

3 WEDNESDAY *Setsubun-sai (Shinto)*

4 THURSDAY

5 FRIDAY

6 SATURDAY *Waitangi Day (NZ)*

7 SUNDAY

NOTES

February

8 MONDAY *Nirvana Day (Buddhist)*

9 TUESDAY

10 WEDNESDAY

11 THURSDAY

12 FRIDAY *Chinese New Year*

13 SATURDAY

14 SUNDAY *Valentine's Day*

NOTES

February

15 MONDAY *Presidents' Day (US)*

16 TUESDAY *Vasant Panchami (Hindu), Shrove Tuesday (Christian)*

17 WEDNESDAY *Ash Wednesday (Christian)*

18 THURSDAY

19 FRIDAY

20 SATURDAY

21 SUNDAY

NOTES

February

22 MONDAY

23 TUESDAY

24 WEDNESDAY

25 THURSDAY

WEEK 8

26 FRIDAY *Purim (Jewish)*

27 SATURDAY

28 SUNDAY

NOTES

WEEK 8

February

March

1 MONDAY

2 TUESDAY

3 WEDNESDAY

4 THURSDAY

5 FRIDAY

6 SATURDAY

7 SUNDAY

NOTES

March

8 MONDAY *International Women's Day*

9 TUESDAY

10 WEDNESDAY

11 THURSDAY *Maha Sivaratri (Hindu)*

12 FRIDAY

13 SATURDAY

14 SUNDAY *Clocks change (Can/US)*

NOTES

March

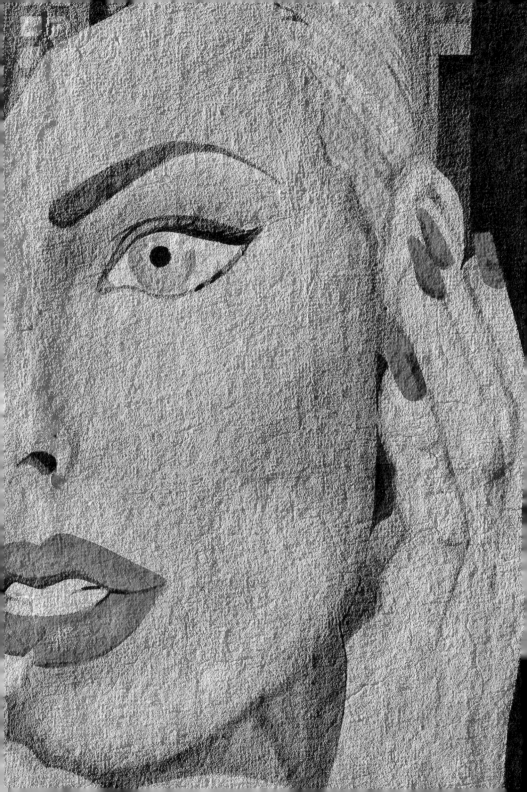

15 MONDAY

16 TUESDAY

17 WEDNESDAY *St Patrick's Day (Ireland)*

18 THURSDAY

19 FRIDAY

20 SATURDAY *Equinox*

21 SUNDAY

NOTES

March week 11

22 MONDAY *World Water Day*

23 TUESDAY

24 WEDNESDAY

25 THURSDAY

26 FRIDAY

27 SATURDAY

28 SUNDAY *Clocks change (Europe), Passover begins (Jewish),*
Palm Sunday (Christian)

NOTES

March

29 MONDAY *Holi (Hindu) Hola Mahalla (Sikh)*

30 TUESDAY

31 WEDNESDAY

NOTES

March

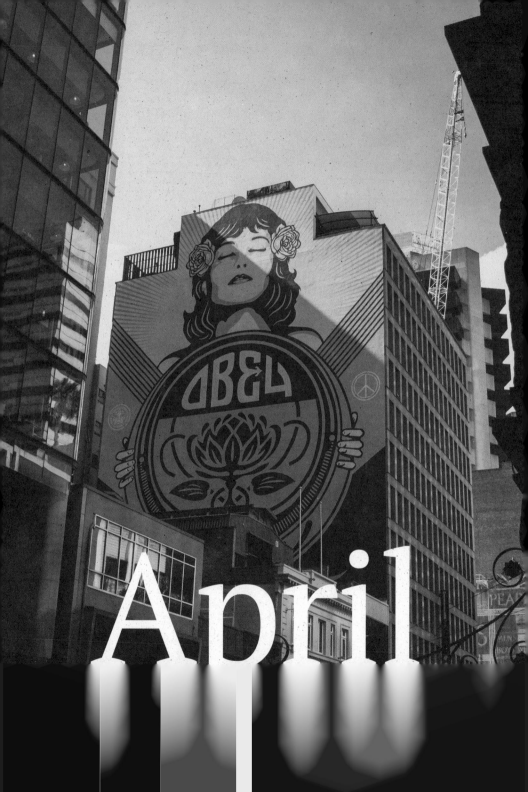

'*The question I seek to answer is: how do we meet the needs of all people within the means of the planet? My big – but simple – vision is this idea of a doughnut. In the middle, there's a hole where people are falling short on the essentials of life – food, healthcare, education and housing. The outer ring is the ecological ceiling of resource use: climate change, freshwater stress, biodiversity loss. The doughnut is the safe space between these two.*'

Kate Raworth, British renegade economist

KATE RAWORTH

2 FRIDAY *Good Friday (Christian)*

3 SATURDAY

4 SUNDAY *Clocks change (Aus/NZ), Easter Day (Christian)*

NOTES

April WEEK 13

5 MONDAY *Public holiday (Aus, Can, NZ, UK except Scot)*

6 TUESDAY

7 WEDNESDAY *World Health Day*

8 THURSDAY *Yom Hashoah (Jewish), Visakha Puja (Buddhist)*

9 FRIDAY

10 SATURDAY

11 SUNDAY

NOTES

April

12 MONDAY

13 TUESDAY *Ramadan begins (Muslim)*

14 WEDNESDAY *Baisakhi (Sikh New Year)*

15 THURSDAY

16 FRIDAY

17 SATURDAY

18 SUNDAY

NOTES

April

19 MONDAY

20 TUESDAY

21 WEDNESDAY

22 THURSDAY *Earth Day*

23 FRIDAY

24 SATURDAY

25 SUNDAY *Anzac Day (Aus/NZ)*

NOTES

April

26 MONDAY

27 TUESDAY *Theravada Buddhist New Year*

28 WEDNESDAY

29 THURSDAY

NOTES

'*I'm bringing a message from the forgotten rural women, from the most remote regions where the government has no presence. We must enter power and they have to see that we are coming!*'

VANESSA BAIRD

Virginia Pinares, Peruvian indigenous human rights defender

April

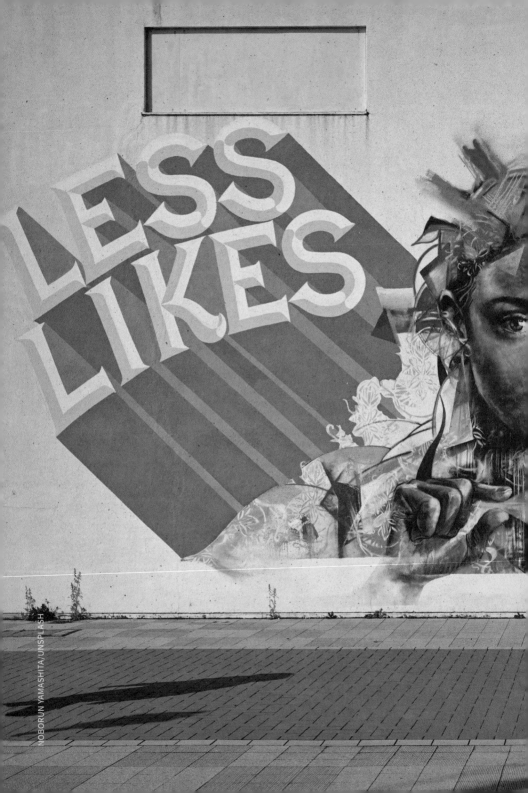

LESS LIKES

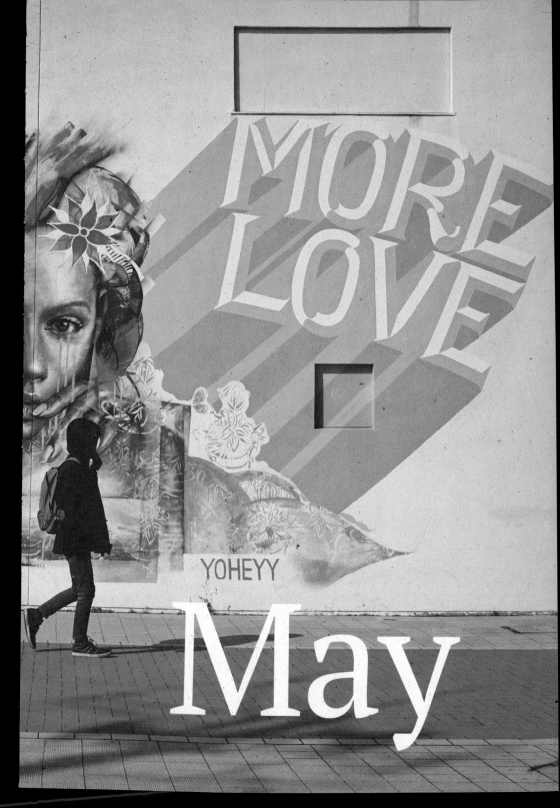

MORE LOVE

YOHEYY

May

'We have to keep fighting. If we choose to be mute spectators, it would be the victory of evil and injustice.'

Soni Sori, teacher and indigenous human rights defender from Bastar, in the Indian state of Chhattisgarh

1 SATURDAY *International Workers'.Day, Beltane/Samhain (Wicca)*

2 SUNDAY

NOTES

May

3 MONDAY *Public holiday (UK)*

4 TUESDAY

5 WEDNESDAY

6 THURSDAY

WEEK 18

7 FRIDAY

8 SATURDAY

9 SUNDAY

NOTES

May

10 MONDAY

11 TUESDAY

12 WEDNESDAY

13 THURSDAY *Eid al Fitr (Muslim), Ascension Day (Christian)*

14 FRIDAY

15 SATURDAY

16 SUNDAY

NOTES

May

17 MONDAY *Shavuot begins (Jewish)*

18 TUESDAY

19 WEDNESDAY

20 THURSDAY

21 FRIDAY

22 SATURDAY

23 SUNDAY *Pentecost (Christian)*

NOTES

May

24 MONDAY *Victoria Day (Canada)*

25 TUESDAY

26 WEDNESDAY

27 THURSDAY

28 FRIDAY

29 SATURDAY *Ascension of the Baha'u'llah (Baha'i)*

30 SUNDAY

NOTES

NOTES

DENISE NESTOR

'*When I took the trip, I didn't think about rescue. No-one thinks about this when they are fleeing. It sounds like they [Europe] prefer dead bodies to live people.*'

Amel al-Zakout, Syrian artist, talking about her experience of being saved by a volunteer lifeguard when her boat capsized en route to Greece

WEEK 22

May

June

> *There are no heroes in Yemen – only criminals and victims. And these criminals are failures! That's why peace is possible.'*
>
> **Radhya al Mutawakei,** Yemeni human rights defender

1 TUESDAY

2 WEDNESDAY

3 THURSDAY

4 FRIDAY

5 SATURDAY

World Environment Day

6 SUNDAY

NOTES

June

7 MONDAY *Queen's Birthday (NZ)*

8 TUESDAY *World Oceans Day*

9 WEDNESDAY

10 THURSDAY

11 FRIDAY

12 SATURDAY

13 SUNDAY

NOTES

June

14 MONDAY — Queen's Birthday (Aus)

15 TUESDAY

16 WEDNESDAY

17 THURSDAY

18 FRIDAY

19 SATURDAY

20 SUNDAY *World Refugee Day, Pentecost (Orthodox Christian)*

NOTES

June WEEK 24

21 MONDAY *Solstice*

22 TUESDAY

23 WEDNESDAY

24 THURSDAY

25 FRIDAY

26 SATURDAY

27 SUNDAY

NOTES

June

28 MONDAY

29 TUESDAY

0 WEDNESDAY

NOTES

June

'The ruling ideology like to invoke the line that we're manipulated, but we can't do anything, so just enjoy your life. But when people are aware in their bodies and minds of issues like global warming, migration, the economic 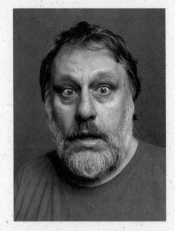 *crisis and so on, this can gradually give them the force to do something. Don't underestimate people.'*

Slavoj Žižek, Slovenian philosopher, sociologist and cultural critic

Canada Day (Can)

2 FRIDAY

3 SATURDAY

4 SUNDAY *Independence Day (US)*

NOTES

July

5 MONDAY

6 TUESDAY

7 WEDNESDAY

8 THURSDAY

9 FRIDAY

10 SATURDAY

11 SUNDAY

NOTES

July WEEK 27

12 MONDAY

13 TUESDAY *Obon (Shinto)*

14 WEDNESDAY

15 THURSDAY

16 FRIDAY

17 SATURDAY

18 SUNDAY

NOTES

July

19 MONDAY

20 TUESDAY *Eid al Adha (Muslim)*

21 WEDNESDAY

22 THURSDAY

23 FRIDAY

24 SATURDAY

25 SUNDAY

NOTES

July

26 MONDAY

27 TUESDAY

28 WEDNESDAY

29 THURSDAY

30 FRIDAY

31 SATURDAY

NOTES

July

August

'We call it the "urbicide" of Syria. Genocide is the act of deliberately killing a group with a certain identity. Urbicide is how you do this to a city: in Syria, the regime is weaponizing urban planning to engineer demographic change and "cleanse" certain groups.'

Sawsan Abou Zainedin, Syrian architect and urban planner, currently in exile in London

ALESSIO PERRONE

1 SUNDAY

NOTES

August

2 MONDAY *Public holiday (Scot)*

3 TUESDAY

4 WEDNESDAY

5 THURSDAY

6 FRIDAY

7 SATURDAY

8 SUNDAY

NOTES

August

9 MONARY

10 TUESDAY *Hijra/New Year (Muslim)*

11 WEDNESDAY

12 THURSDAY *International Youth Day*

WEEK 32

13 FRIDAY

14 SATURDAY

15 SUNDAY

NOTES

August

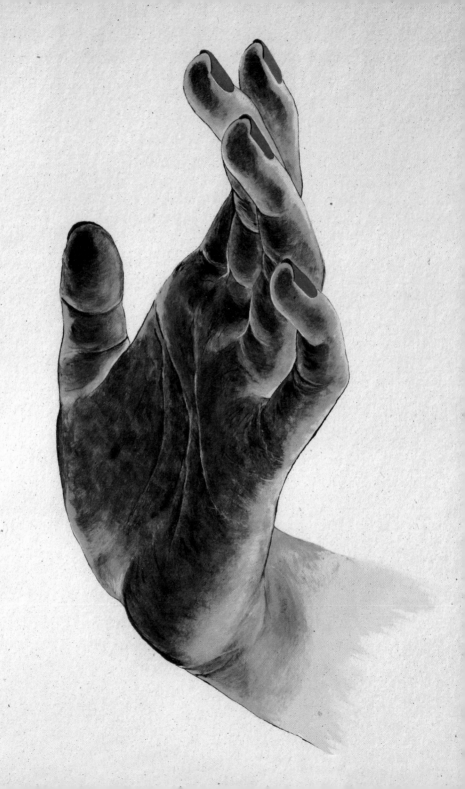

16 MONDAY

17 TUESDAY

18 WEDNESDAY

19 THURSDAY *Ashura (Muslim)*

20 FRIDAY

21 SATURDAY

22 SUNDAY

NOTES

August

23 MONDAY

24 TUESDAY

25 WEDNESDAY

26 THURSDAY

27 FRIDAY

28 SATURDAY

29 SUNDAY

NOTES

August WEEK 34

30 MONODAY *Public Holiday (UK except Scot)*

31 TUESDAY

NOTES

August

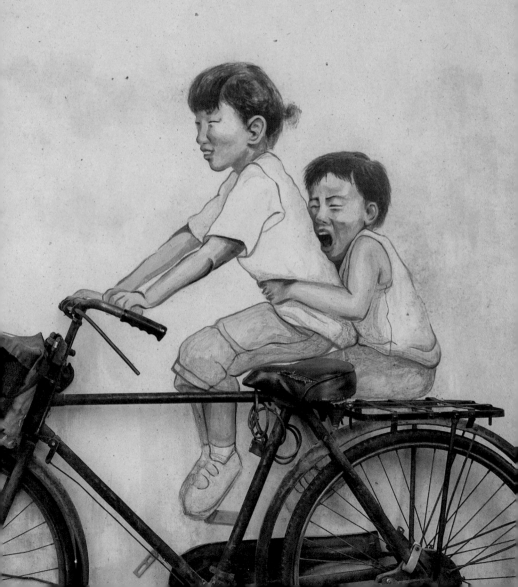

HODA AFSHAR

'I understand this book as a piece of art, then as a piece of Australia's dark history. What the Australian government introduced to the world [through its border protection policy] is only a new kind of fascism and barbarism.'

Behrouz Boochani, Kurdish-Iranian refugee who has since 2014 been imprisoned on Manus Island in Papua New Guinea, which is used as a *de facto* prison for asylum-seekers heading to Australia. While imprisoned, he wrote a book using WhatsApp and a smuggled phone. In 2019 *No Friend but the Mountains: Writings from Manus Island Prison* won the $70,000 Victorian Prize for Literature

1 WEDNESDAY

2 THURSDAY

3 FRIDAY

4 SATURDAY

5 SUNDAY

NOTES

September

6 **MONDAY** *Labour Day (Can), Labor Day (US)*

7 **TUESDAY** *Rosh Hashanah begins (Jewish)*

8 **WEDNESDAY**

9 **THURSDAY**

10 FRIDAY

11 SATURDAY

12 SUNDAY

NOTES

September WEEK 36

13 MONDAY

14 TUESDAY

15 WEDNESDAY

16 THURSDAY *Yom Kippur (Jewish)*

17 FRIDAY

18 SATURDAY

19 SUNDAY

NOTES

20 MONDAY

21 TUESDAY *Sukkot begins (Jewish)*

22 WEDNESDAY *Equinox*

23 THURSDAY

24 FRIDAY

25 SATURDAY

26 SUNDAY *Clocks change (NZ)*

NOTES

September

27 MONDAY

28 TUESDAY

29 WEDNESDAY

30 THURSDAY

1 FRIDAY

2 SATURDAY

3 SUNDAY *Clocks change (Australia)*

NOTES

October

4 **MONDAY** *Labour Day (Aus)*

5 **TUESDAY** *World Teachers' Day*

6 **WEDNESDAY** *Navaratri begins (Hindu)*

7 **THURSDAY**

8 FRIDAY

9 SATURDAY

10 SUNDAY

NOTES

October

11 MONDAY *Thanksgiving (Can), Indigenous Peoples' Day/Columbus Day (US)*

12 TUESDAY

13 WEDNESDAY

14 THURSDAY

15 FRIDAY

16 SATURDAY *World Food Day*

17 SUNDAY

NOTES

October

18 MONDAY *Mawlid al-Nabi (Sunni Muslim)*

19 TUESDAY

20 WEDNESDAY

21 THURSDAY

22 FRIDAY

23 SATURDAY *Mawlid al-Nabi (Shia Muslim)*

24 SUNDAY

NOTES

October WEEK 42

25 MONDAY · *Labour Day (NZ)*

26 TUESDAY

27 WEDNESDAY

28 THURSDAY

29 FRIDAY

30 SATURDAY

31 SUNDAY *Clocks change (Europe), Halloween*

NOTES

October

N

ovember

1 MONDAY

2 TUESDAY

3 WEDNESDAY

4 THURSDAY *Diwali (Hindu, Sikh, Jain)*

5 FRIDAY

6 SATURDAY

7 SUNDAY *Clocks change (Can/US)*

NOTES

November

8 MONDAY

9 TUESDAY

10 WEDNESDAY

11 THURSDAY *Veterans' Day (US); Remembrance Day (Can)*

12 FRIDAY

13 SATURDAY *Jain New Year*

14 SUNDAY

NOTES

November

15 MONDAY

16 TUESDAY

17 WEDNESDAY

18 THURSDAY

19 FRIDAY

20 SATURDAY

21 SUNDAY

NOTES

November

22 MONDAY

23 TUESDAY

24 WEDNESDAY

25 THURSDAY

Thanksgiving (US),
International Day for the elimination of violence against women

26 FRIDAY

27 SATURDAY

28 SUNDAY

First Sunday of Advent (Christian)

NOTES

November

29 MONDAY · *Hanukkah begins (Jewish)*

30 TUESDAY

NOTES

November

> '*If art is not subversive, if you're not challenging the status quo, if you're not creating something new or imagining alternatives to a grim reality, what are you doing? You're just mirroring reality. That's not interesting to me. I can see reality, I can see how grim it is. I want something that helps me imagine a better world – more empowered women or communities. Art should be able to piss people off. If your work is not pissing people off, I don't think it's good work!*'

MS SAFFAA

Ms Saffaa, Saudi Arabian street artist

1 WEDNESDAY *World AIDS Day*

2 THURSDAY

3 FRIDAY

4 SATURDAY

5 SUNDAY

NOTES

December

6 MONDAY

7 TUESDAY

8 WEDNESDAY

9 THURSDAY

10 FRIDAY

11 SATURDAY

12 SUNDAY

NOTES

December

13 MONDAY

14 TUESDAY

15 WEDNESDAY

16 THURSDAY

17 FRIDAY

18 SATURDAY

19 SUNDAY

NOTES

December WEEK 50

20 MONDAY

21 TUESDAY *Solstice*

22 WEDNESDAY

23 THURSDAY

24 FRIDAY

25 SATURDAY *Christmas Day (Christian)*

26 SUNDAY *Boxing Day*

NOTES

December

27 MONDAY *Public holiday (Aus, Can, NZ, UK)*

28 TUESDAY *Public holiday (Aus, Can, NZ, UK)*

29 WEDNESDAY

30 THURSDAY

NOTES

'Basically they were trying to get me to agree to shut up. It's not easy being a journalist in Bangladesh. I know people who have been abducted and never returned, others who returned as different people, who never ever spoke of what had happened to them and had given up being vocal and critical of the government.'

Shahidul Alam, Bangladeshi photojournalist, talking about his experience of detention and torture in 2018-19

December

WEEK 52

Notes